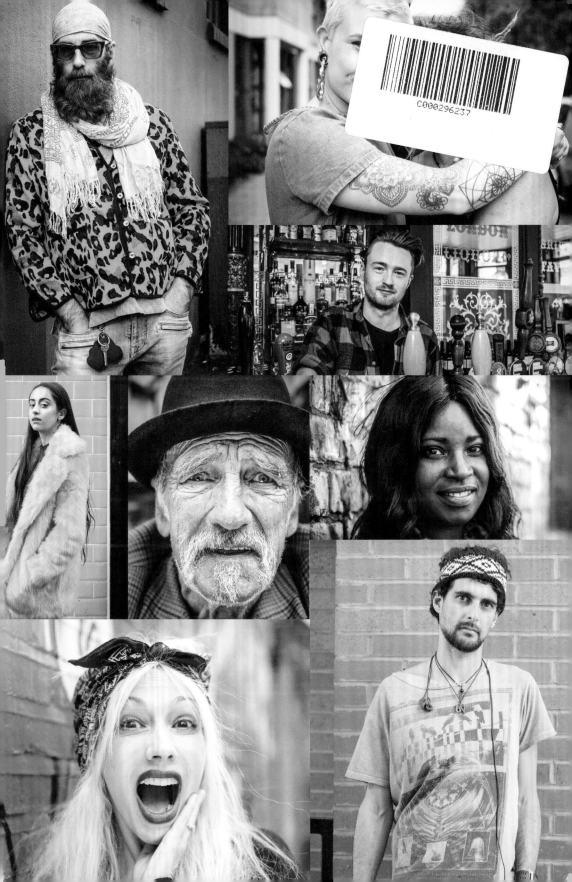

First published 2017

Amberley Publishing
The Hill, Stroud
Gloucestershire, GL5 4EP

www.amberley-books.com

British Library Cataloguing in Publication Data.
A catalogue record for this book is available from the British Library.

ISBN 978 1 4456 5928 2 (print)
ISBN 978 1 4456 5929 9 (ebook)

Typesetting and Origination by Amberley Publishing.
Printed in Great Britain.

FOREWORD

Dear reader,

First of all, thank you for picking up this book. Its creation spanned the best part of a year, and was a labour of love by a portrait photographer with a long-standing fondness of this colourful and ever-changing area.

The core 'Shoreditch triangle', as it is known today, is bordered by Shoreditch High Street, Great Eastern Street and Old Street. However, in everyday conversation and popular culture, 'Shoreditch' is often also used to refer to the top end of Brick Lane down to Hanbury Street, the Old Truman Brewery and Bethnal Green Road towards Shoreditch High Street station – overall a considerably larger area than the triangle. Historically, the parish of Saint Leonard Shoreditch stretched even farther, covering today's Haggerston, Hoxton, Moorfields, Kingsland and more. When deciding on the extent of geographical coverage for this book I took the above into consideration, and therefore ventured slightly further than the core triangle.

Through the seventy-three documentary portraits and quotes in this book, I want to give you a glimpse into the diversity, delights and challenges of Shoreditch life today. Be it long-time locals with working-class roots, creative but concerned small businesses or new residents drawn to the energy and promise of an upcoming area; the book's aim is to provide several sides of the story. It doesn't take sides or suggest solutions – that's up to the reader to reflect upon. Regardless of what might come in Shoreditch's future, its past and present are already one of the most fascinating and colourful ones a London neighbourhood can offer. I hope you will enjoy coming back to this book from time to time, and will be inspired by the people and stories it contains.

I would like to thank Amberley Publishing for the opportunity to create this book; my portrait subjects for so kindly sharing a snippet of their lives with me; the P Collective guys for their feedback when I needed it; Tamas for helping with the editing; and my husband David for being wonderfully patient and supportive even when I was spending all my spare time on this project!

Barbara Asboth

GRAHAM BUCK
OWNER, THE BLACK CAB COFFEE COMPANY

I started this business in Shoreditch two and a half years ago. I started it here because I like the friendliness and multicultural aspect of the place. The idea for the black cab came from my first date with my fiancée, when she picked me up in one! I also took part in the filming of the movie Now You See Me *with this cab; I was in the background, looking surprised while making coffee, as police arrived on the scene!*

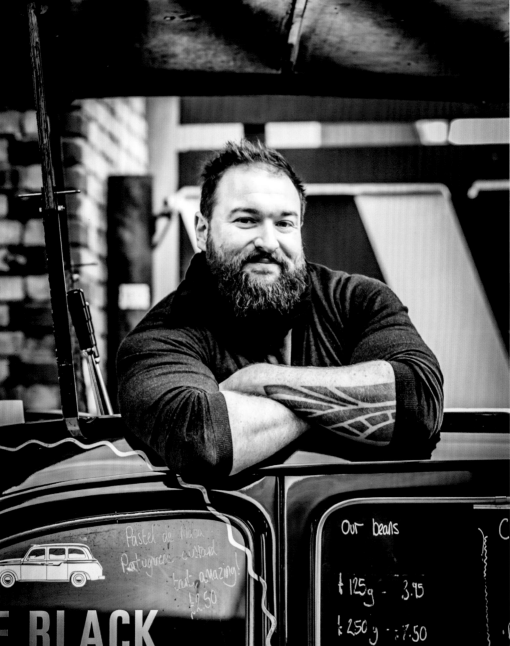

Our beans

½ 125 g - 3.95
½ 250 g - 7.50
½ 500 g - £ 14.95
We can take
CARD payments!

Pastel de Nata
Portuguese custard
tart, amazing!
£2.50

E BLACK
COFFEE C⁰

LONDON

FACES OF SHOREDITCH

WESLEY
LOCAL RESIDENT

I've lived here for twenty-five years and just love it. Oh, it's changed. My street now is upmarket, beautiful houses. They say the East End is all lowlifes, but that's bullshit; it's right up there. In my street the houses are 300 years old, and were mostly a pile of rubble before, but they rebuilt them as exact replicas of their original designs, and they're really beautiful. I've even got my own ghost — I have, honest! She comes to see me on my birthday every year. It's not scary at all. She just stands there and watches over me. Maybe she was a previous lover in a past life.

LAURIE MACKRELL
MARKETING EXECUTIVE, MARSH & PARSONS ESTATE AGENT

I've worked in Kensington before, and over here the dynamic between clients, landlords and developers is completely different — it's a whole other world, although the gentrification happening here is bringing those people in. I think it'll be less and less diversified in the future. For now, we tend to get younger customers in Shoreditch than in the other offices; we have a lot of people working in the City and we do a lot of corporate relocations. Generally we have more students than other offices as well, due to the various universities in the area. The prices have historically been lower than in West London. I love this area; I would buy a property here if I could. It's one of the first areas I'd look as it has very good investment potential. I wouldn't resist any development around here.

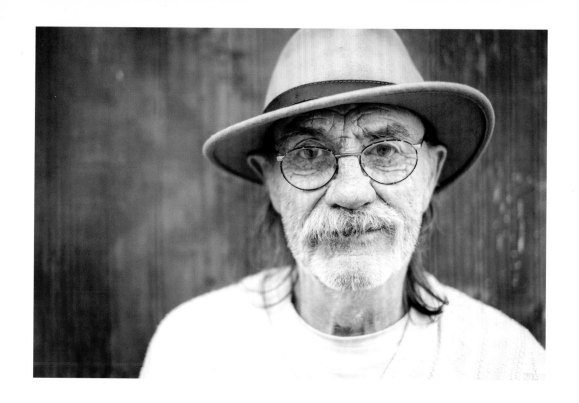
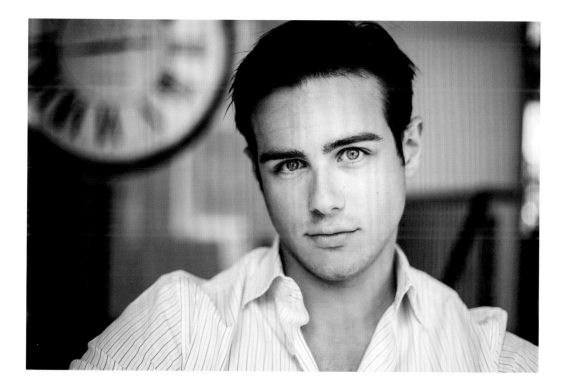

ABBIE MIRANDA AND MAZIE GARDNER
OWNERS, BEIJA FLOR LINGERIE POP-UP

Our tagline is 'modern lingerie for real life' — and real life is not silk underwear! We're trying to marry feminism with femininity. It's a reaction to everything on the high street at the moment: bows, retro, burlesque — that's not what anyone I know wears. I live nearby and the area is getting gentrified but that's not necessarily a bad thing, because it makes the place nicer, cleaner and safer. For local businesses it's good too, with people having more money to spend. On the flip side though, people who've lived here for forty years and bought their council houses in my block are now getting enormous work bills during renovations and are struggling with the payments. The changes just have to be controlled, because otherwise the appeal of the area won't be what it was originally.

MICK TAYLOR
LOCAL RESIDENT

I wear a suit every day; I have six or seven of them. You've got to wear nice shoes too; you never know who you're going to meet.

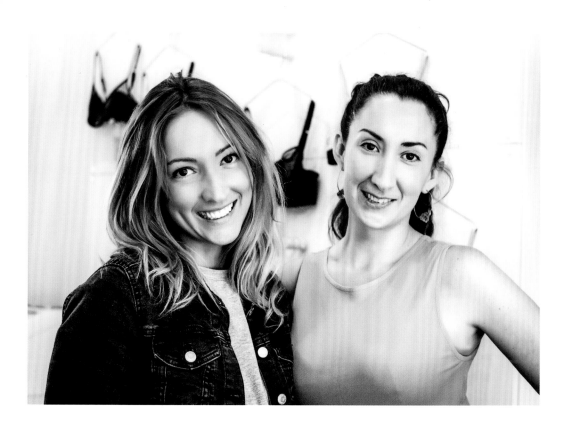

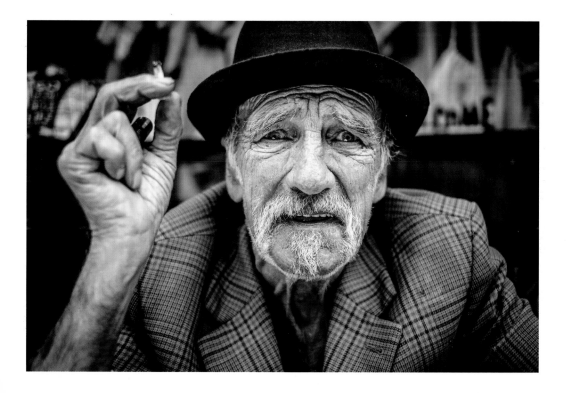

FACES OF SHOREDITCH

NAZIM
SUPERMARKET CASHIER

I'm from Bangladesh, and I've been in this country for more than eighteen years. There is a good Bangladeshi community in this area. Bangladeshi people like their social life, always, from generation to generation. So we all live in the area, and one family helps another.

NATASHA
3D ARTIST

Shoreditch means creativity and sharing of ideas, and people feeling able to do that regardless of what their speciality is. It gives us an opportunity to do something like this exhibition, bringing in our work, which is traditionally seen as quite geeky, and showing it in a really beautiful, creative space. This is the heart of creativity in London, where everyone from different areas of design can come together.

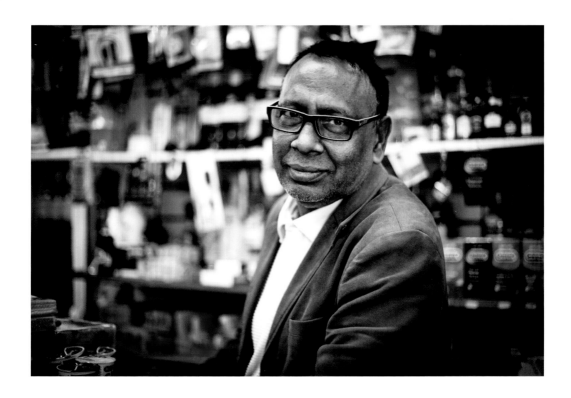

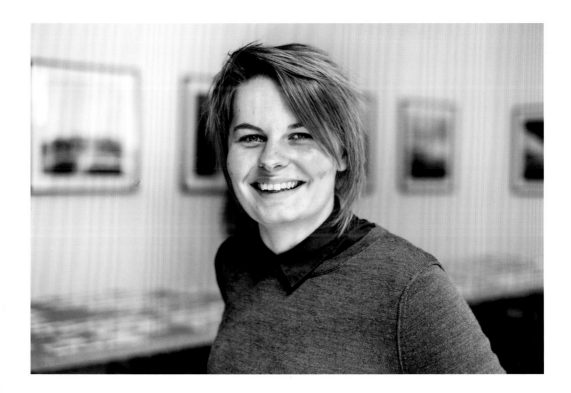

NAS
VISUAL ARTIST

Being from West London originally, Shoreditch is such a different area. You've got more freedom of expression in clothing, art styles, and you have all the independent businesses. There's a lot of creativity here. A lot of pretentiousness as well (laughs), but still there's that heavy art and design culture that I really appreciate.

LAUREN PEARS
OWNER, LADY DINAH'S CAT EMPORIUM

The one thing I feel is common for all our customers is that coming to Lady Dinah's is something of a special treat, to escape a bit from reality. You can hear people making happy noises when they play with the cats; you don't see that anywhere else! We've been fully booked ever since we opened, but we do have to limit guest numbers to ensure the cats don't get too tired! I chose this location for the café because this is where three out of London's four most densely populated boroughs intersect, and I assumed fewer people would be able to have pets at home — that was the logical reason. But it turned out to be an emotional fit as well: being part of this community, working together. We pick up bagels from the bagel shop, milk from the off-licence next door, for example. I recently also started up a group for managers and owners from different Shoreditch venues to foster that sense of community and to work out how we can work together. With the economic climate changing, we aim to have each other's back.

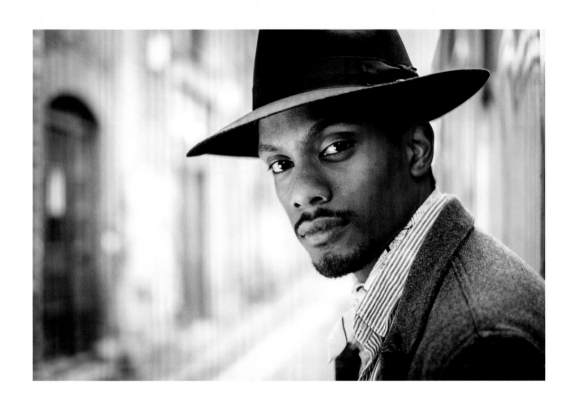
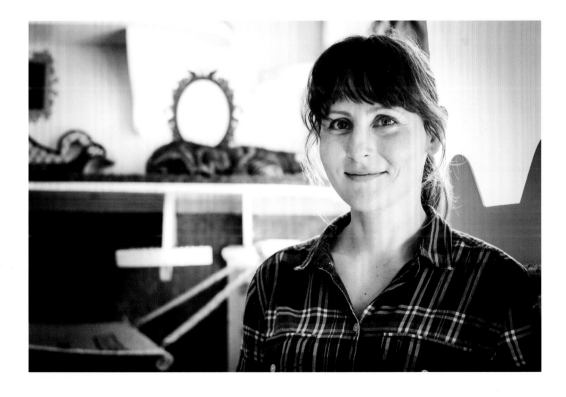

MARTIN
POLICE INSPECTOR

This job in Shoreditch is the best thing that's ever happened to me. I love the area and socialise here after work too. I was a PC at Bethnal Green when I started in the 80s. I was promoted to inspector eleven years ago and I now run the south Hackney Safer Neighbourhood teams. My teams deal with burglary, drugs and local gangs as well. In Shoreditch we have to deal with laughing-gas balloon sellers, for example. It sounds harmless at first, but it can cause of a lot of turf wars between gangs and it's illegal to sell now. We've successfully pushed the gangs further out. Another important aspect of our job involves the night-time economy: assaults, theft and antisocial behaviour are the top three reasons for the calls we receive. We have a sergeant and eight PCs to cover quite a large area. We can't flood the place with police and I don't think people want to see it over-policed anyway, so we work with clubs and bars, relying heavily on help from them to prevent problematic activity. This kind of problem solving is the biggest challenge of my job and also the most enjoyable part. Our system works really well for us, because it's also in the club owners' interests to keep crime in check. There's a private chat group online that the clubs run. They can talk to each other really quickly that way, and it's helped us capture wanted criminals. We have a biweekly meeting with door staff too. You see, it's the door staff, bin men, those kinds of people in the community who can help us notice wanted criminals, thieves or other suspicious individuals.

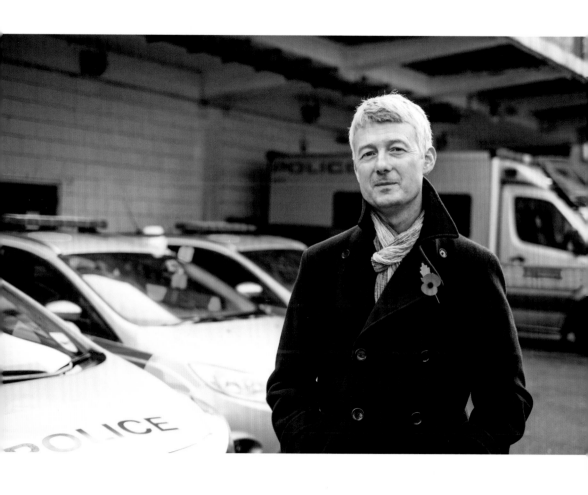

FACES OF SHOREDITCH

DWIGHT
BAKER

Shoreditch is not what it used to be. It used to be a lot tougher but now there's construction going on – lots of new buildings – and it's much less so. It's still vibrant, and I love the people. I'm at the stall every Saturday. Some customers come all the way from West London to shop here!

RICHMOND
STYLIST

I'm here for the Alexander Wang drop for Fashion Week – that's what's in the bag. I'm from Los Angeles and getting used to the chilly weather here is hard!

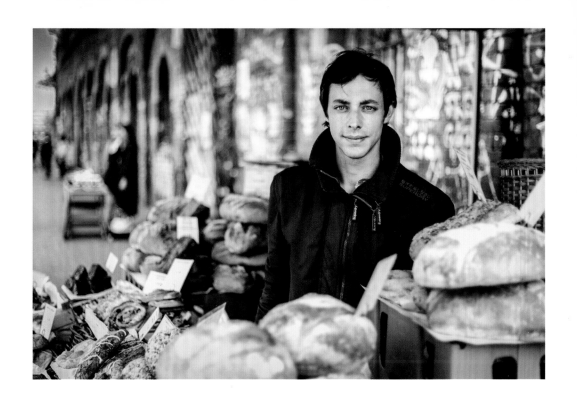

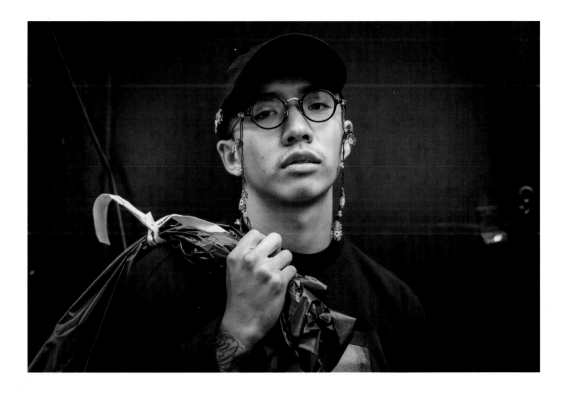

FACES OF SHOREDITCH

FERDOUS
BUSINESS CONSULTANT

It's lovely living here, so much fun. I'd like to invite all of the people of London to come over here, to see how fantastic Shoreditch is!

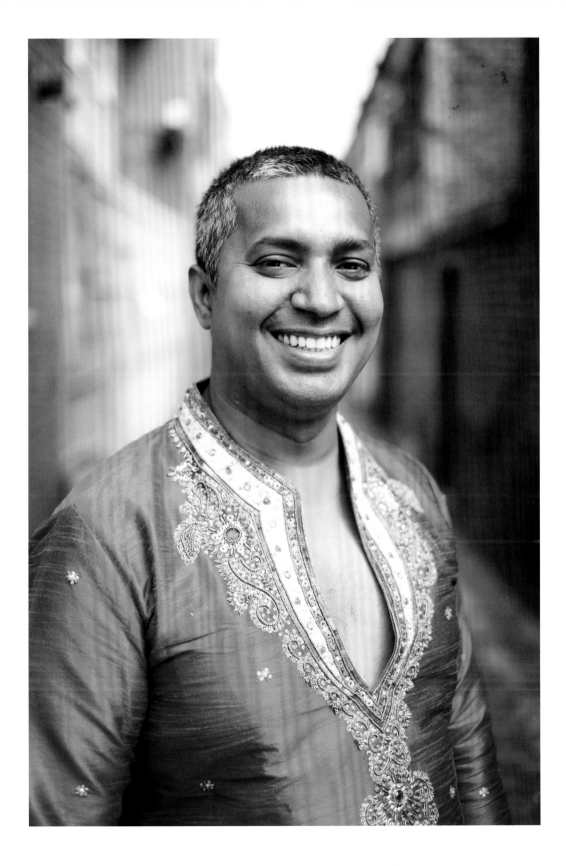

FACES OF SHOREDITCH

ISAAC
LOCAL RESIDENT

I'm originally from a surf town in Australia. Shoreditch is everything my hometown isn't, and that's why I love it. It's convenient for nights out, my mates can stop by all the time on their way to a club, and it's walking distance from everything I need in general. The best part though, for me, is the basketball court nearby where I can just turn up and play with whoever's there.

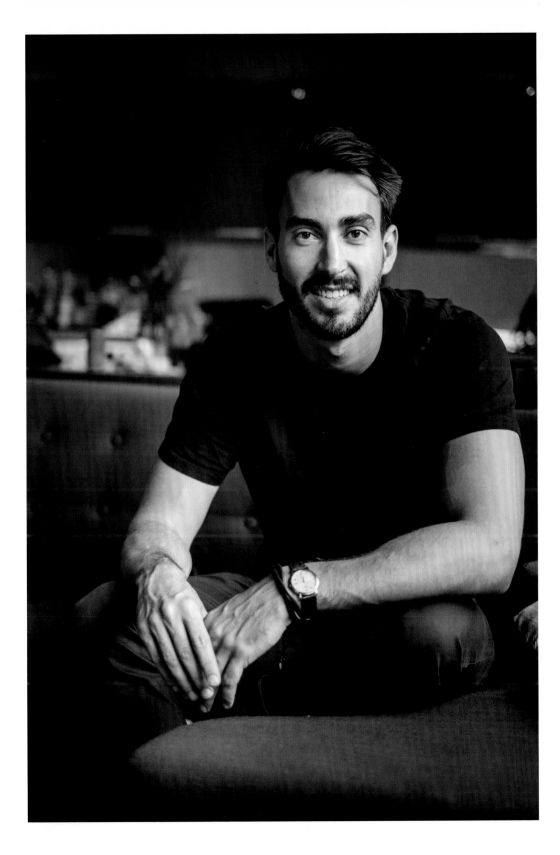

CLARE
WRITER

I'm from Australia and I came here because I grew up watching British comedy. At the moment I'm writing a pilot for a TV series. I know a lady here who's been living in the area since the Kray brothers were around. She'll tell me stories about how 'they're just nice boys, aren't they', and how 'the good thing about them was that they'd never do anything to you if you didn't do anything to them' ... I'm not too sure what the definition of 'people doing something to them' was!

NIZAM
NEWSAGENT'S SALES ASSISTANT

I've been working here for ten years. We mostly sell lottery cards, soft drinks, and newspapers of course! In the early morning people buy newspapers and travel cards; in the evening it's lots of lottery cards. I recognise about 20 per cent of customers as regulars. Sometimes they come in and even ask me about the business and how it's going — it's very nice of them.

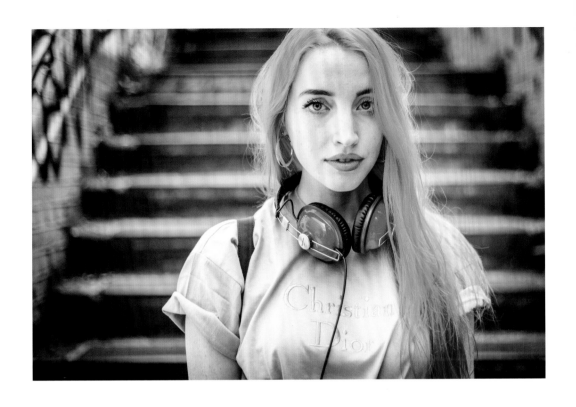

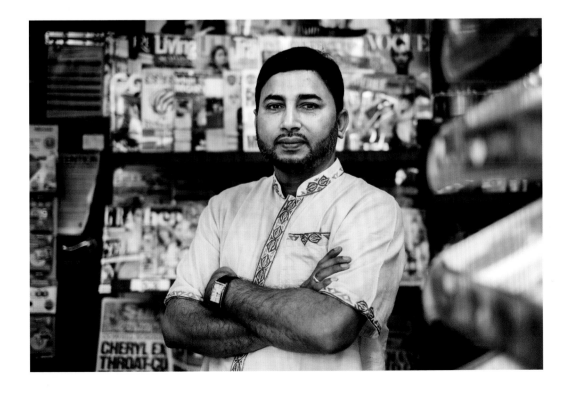

FACES OF SHOREDITCH

LISA SUPPLE
SHOE DESIGNER

You just have to get in and get out. If you loiter for too long it can get a bit frantic! But it's a really nice slice of London life and we're lucky to have it. I am very attached to Shoreditch. I've seen all the change that's occurred and was nervous about it initially, but there's always upsides to these things. You just have to accept that London is in a changing state, and you end up enjoying the progression as much as the change of people coming in. It used to be prostitutes on Commercial Street, now it's hipsters — that's how it is! There's so much inspiration in East London generally. I mean, look at that lady with the tiger-print jacket there. She looks crazy but fabulous, right?

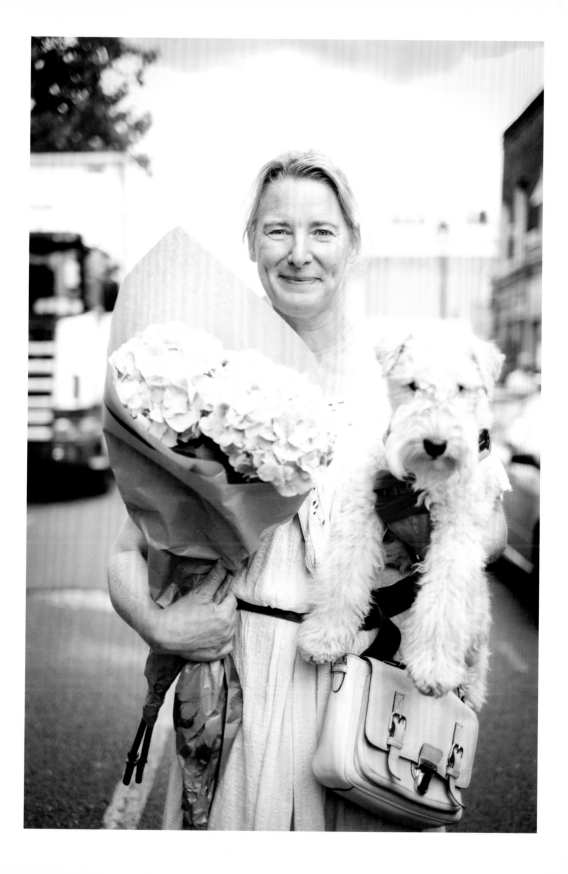

COCO
STAGE MANAGER (IN TRAINING)

I'm rehearsing for a play called Adding Machine at the moment, in the studio around the corner — it's a lot of work but I love it. It'll be performed at the Finborough Theatre.

RICHARD
FORMER LORRY DRIVER

I've been here for seven years; I was a lorry driver before. I've always liked drawing as well, and this picture of a gambler is my favourite. Sometimes I sell my drawings, but I don't ask for favours, don't ask for anything really. If people buy something then great, if not, well, life goes on.

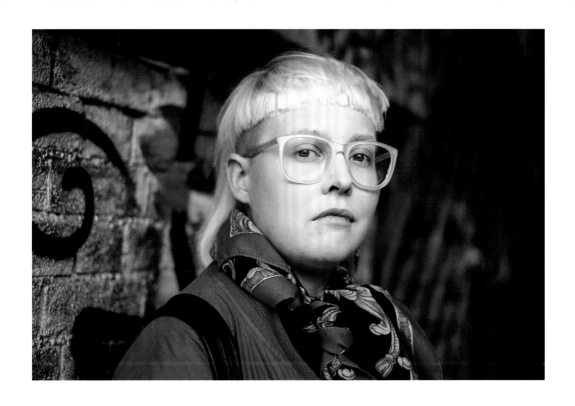
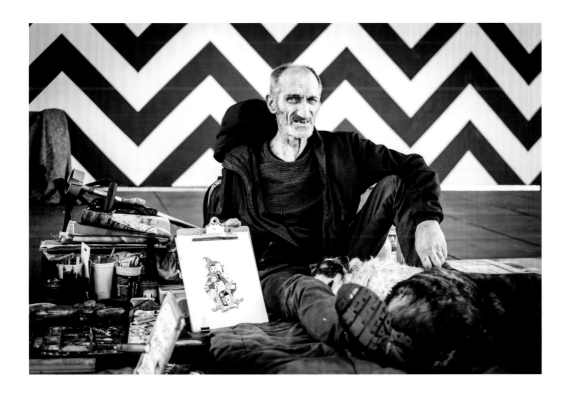

MILTON
MUSIC PRODUCER AND DJ

I used to live alone in Shoreditch, but moved into a shared warehouse for a more social experience. As a music-oriented person, I moved here because the techno house scene is much more inspiring than in Brazil. I've played the Aquarium in Old Street and recently released my own album.

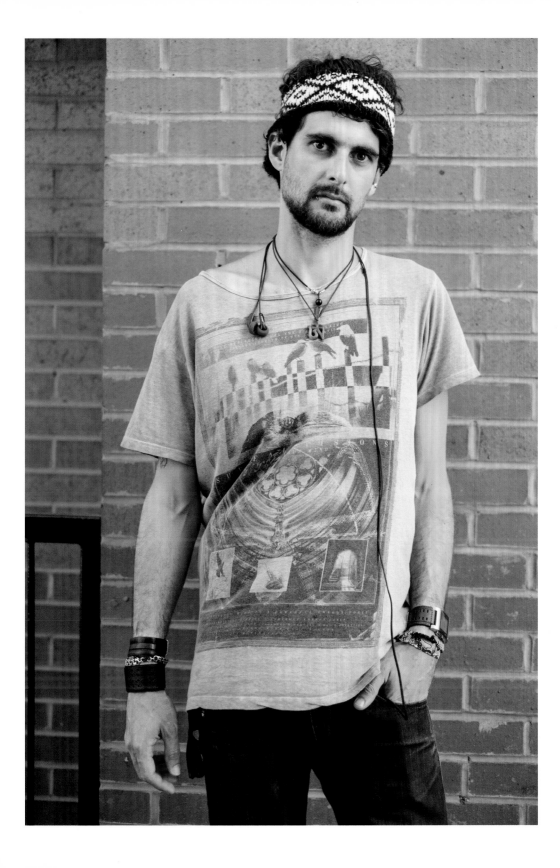

NADINE
YOGA TEACHER

Shoreditch is a mix of people all coming together. I love the diversity; I love the chaos. Compared to where I'm from (Cardiff) there are more opportunities, more of an art scene. People are more interested in the 'other' side of things.

BEN
FORMER FILMMAKER AND SOCIAL SERVICES WORKER

I live in the area and love it. The wall art changes every week — there's always something new to look at. I also love that if you want quiet you can find quiet, but if you want busy it's there too. I've lived in London for thirty years but Shoreditch is what feels like home.

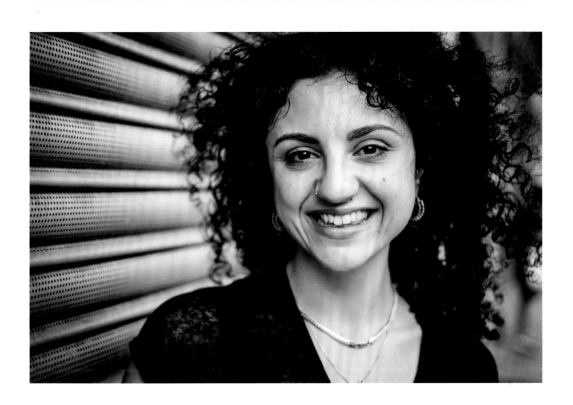
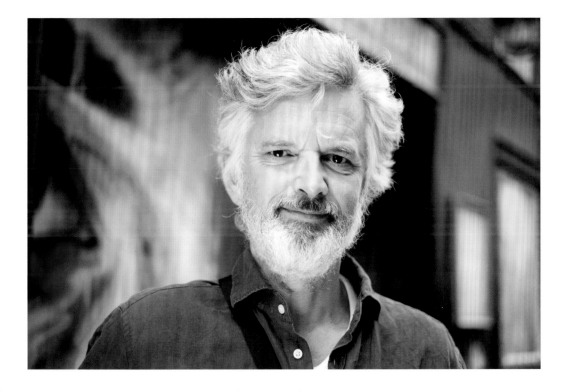

JOSIE WITH MUM ZOE
BODY PIERCER

Everyone seems to express themselves and they are confident in the way they look, who they are — that's why we come here. I feel more like myself here.

ANH DAO
ACCOUNTANT AND BUSINESS OWNER

I first came to live in Shoreditch about ten years ago. Then I moved a bit further north for a while but missed Shoreditch life too much! I ended up coming back and I've now established my permanent home here. I love it because my son's school is around the corner, and my office is nearby too. I also enjoy a lot of the clubs, restaurants, meet-up groups, swimming with my son — there's always something going on! Of course, ten years ago it was very different. There were places I used to feel scared to come to. But it's much better now, and I feel safer, partly because of the improved security at clubs these days. When I went to pubs and clubs before in the West End they didn't always check handbags, but here they check them, so I feel much safer, because you know, anyone could take a gun or some weapons inside. I don't feel like it's an invasion of privacy; actually it makes me feel safe and more comfortable.

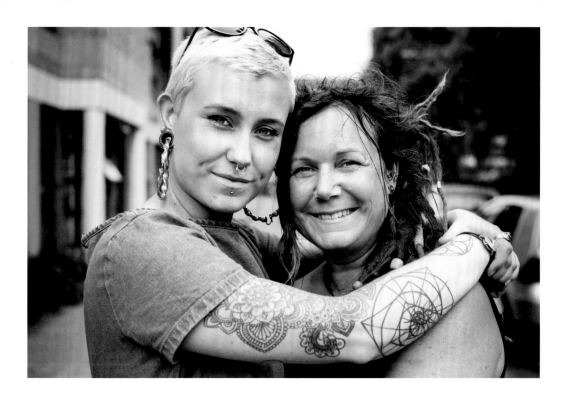

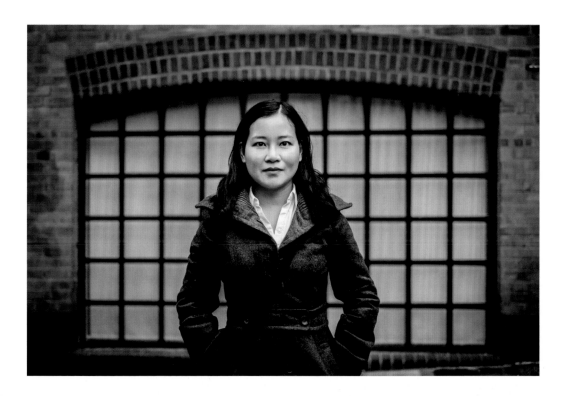

KAREN
CARER

I've lived in the area for seventeen years. I started a career in fashion, but I kept being pulled back toward care work — I guess I loved it more than my career. Last week, my manager told me he couldn't wrap his head around why I'd prefer to clean and wash someone and get nothing for it compared to getting thousands for making a wedding dress. But I think what goes around comes around. My husband helps run our family-owned food stall, and we give out food to the local homeless after we close — I ask them around lunchtime if they want some, and to come over later if they do. It's not everybody that God blesses, and we have to just do what we can.

RAYNES
FORMER THEATRE DESIGNER AND WRITER

There's something wonderful going on in every window!

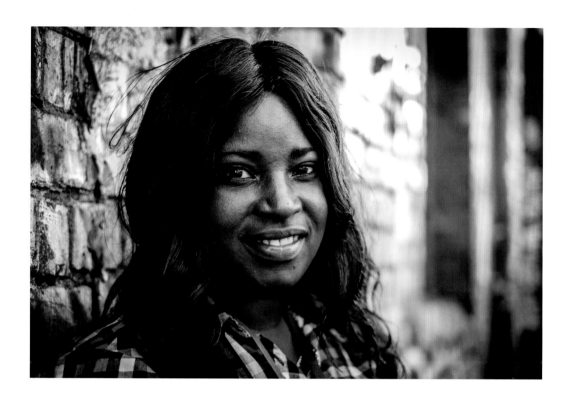

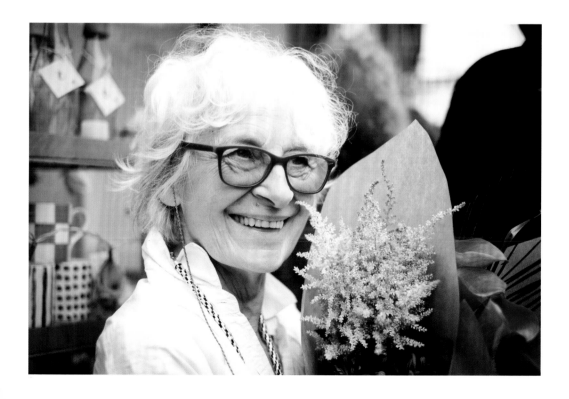

FACES OF SHOREDITCH

JENNIFER
LAWYER

Today I'm here for a walking tour of the local street art spots. I've taken lots of pictures already; there's some amazing stuff around! I never thought Shoreditch had this much street art; there is something on every corner.

'TOM'
LOCAL RESIDENT

How long have I lived here? Over seventy years. Born here, lived here all my life. At one point I was an undertaker. Now I make papier-mache bears and sell them to galleries. Things used to be different, and they were mostly illegal. There were the so-called lock-ins — everything else closed at 11 p.m. so you went into one of these places after that, and only crawled out at maybe 4 a.m. the next morning. That's all gone now, sanitised. It's a real shame.

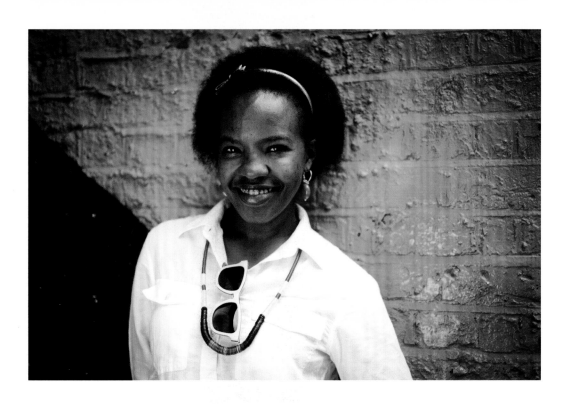
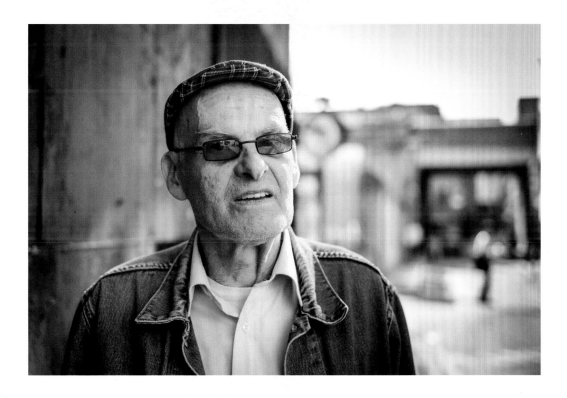

DAVID
PERSONAL TAILOR

I like Shoreditch because coming from Brighton, it's a very similar cultural vibe: lots of independent boutique shops, shoes, jewellery; all kinds of handcrafted stuff. I think we're a bit more formal here than the general fashion of Shoreditch, which is a bit more thrift shop and second hand. Our quirkiness works for us though, because if people want a suit they'll probably come here and get something quirky since that's the kind of thing they'll like.

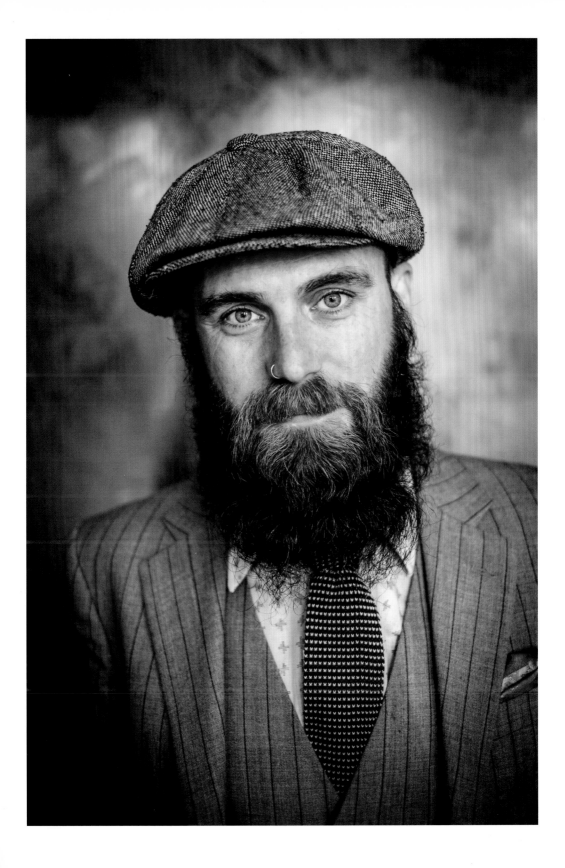

ANOUSHKA
MUSIC STUDENT

Today I planned to buy some fabric here ... and ended up buying clothes. As for this coat... I just bought it on a whim. Well, I thought about it ... for about five minutes!

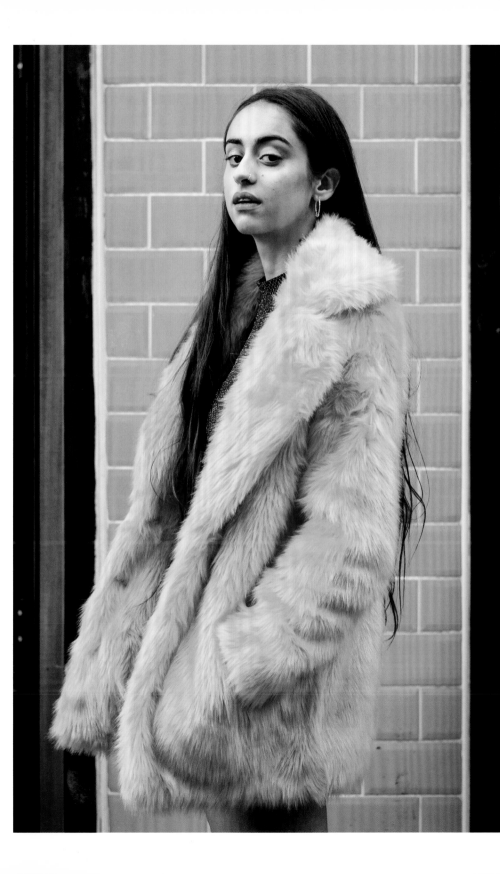

ANDREA
LOCAL RESIDENT

We used to say that Shoreditch is a playground for grown-ups! You knew everybody, there was a close community. It wasn't about trendy kids coming here. There were no hipsters — we were the 'hipsters'. No chains, just independents. The good thing back then was that us locals knew each other, so we didn't have to pay to get into clubs when we went out. There were loads of raves that would be illegal today but of course nobody cared back then. You had to be out on the night, and you found out by word of mouth that there was this dodgy little door to get into the basement where the party was — it was awesome.

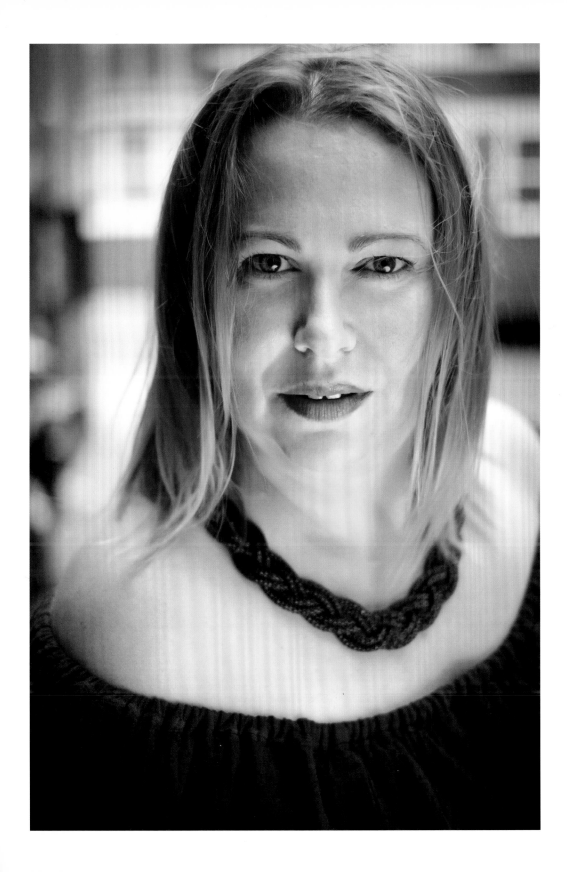

FACES OF SHOREDITCH

REBECCA
MAKE-UP ARTIST

Shoreditch is like a really fun playground for me as a make-up artist. You can get very inspired by all the colours, the people you meet and see — it's that individuality that I crave. It's so cool just to be around here.

LUCA DE GRADI, AKA MR DEGRI
STREET ARTIST

I don't do art for the money, but to build understanding between people. There is always a meaning, a concept behind my artwork. That's why I like to use iconic faces, because it is easy for the viewer to recognise the person, and what that person has done. This works to start a conversation between you and other viewers. My work is often inspired by famous people whose stories are tragic. This portrait behind me is of James Dean, but my favourite painting is one of Chet Baker. The most important thing for me is to deliver a message to the viewer, how much passion I have for free art. If life decides to give me money because of what I do, great; but otherwise I will keep at it anyway.

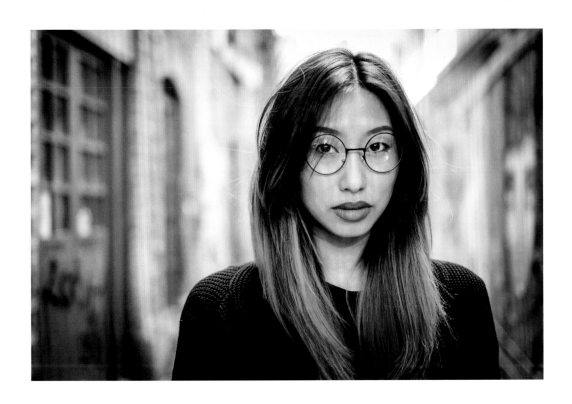

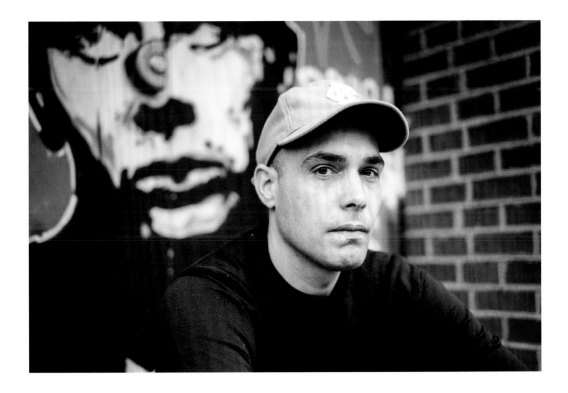

ANTHONY 'DUTCH' VAN SOMEREN
OWNER, THE BIKE SHED

I started a blog about motorcycles and motorcycle culture and it became huge – over 600,000 Facebook followers. About two years ago I decided it should be a real place, not just a virtual one. I talked to bikers who had money, and asked them to give me some; they did and I opened this place in Shoreditch. I knew nothing about running a café, or club; I just made it up as I went along! Shoreditch is a melting pot of weirdness, a bit of everything! It still has a vibe, still has sole traders. It still feels like a place, and let's hope that continues.

MICHELLE
FASHION AGENT AND FOUNDER OF ROLLING PEOPLE SHOWROOM

My husband and I founded our own fashion agency, representing international designers and presenting them to buyers. Every day is different and fashion is constantly evolving – that's what I like most about my job. We chose Shoreditch because it's central and there are lots of showrooms around here. It was also cheaper than the West End at the time, but we may have to reconsider that in the next five years, and move somewhere else, since it's becoming unaffordable.

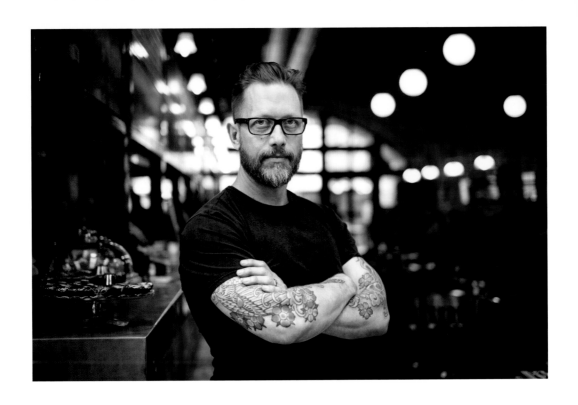
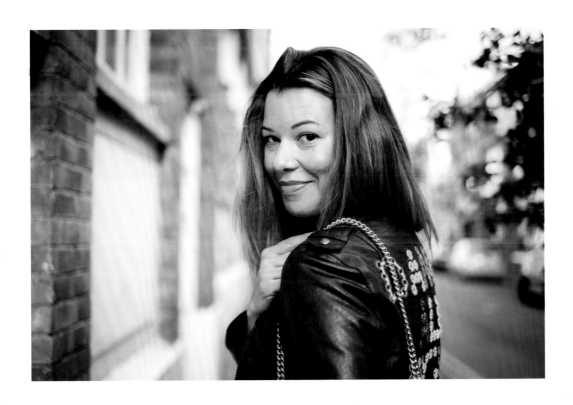

DANIELLE
SOFTWARE ASSET MANAGER

I'm here for a friend's hen night; we're going to karaoke and then a few cocktail bars. Shoreditch is very cool. I love the food, the smells, and the buzzing atmosphere.

ANTHONY
PHOTOGRAPHER

Shoreditch is an amazing place with cool people. This is where young men's fashion and style can really shine.

NANCY, EMILE AND LEILA
LOCAL RESIDENTS AND OWNERS OF NKORA CAFE

We live in the area and like to go to the local community centre's playgroup. The parents there are all really free-spirited, but on the whole there aren't as many parents with young kids living here as further out in London. It seems to me that it's mostly people between twenty and forty. I used to live nearby as a student years ago, and it's very different now. Redchurch Street used to be the 'dodgy street' but now it's actually a nice one.

FACES OF SHOREDITCH

ADAM
MANAGER OF HEADCASE BARBERS

I moved here from Winchester to open this place. Having done research on the area, I felt that Shoreditch and its stylish demographic would be the best option. I'm all about offering high standards at affordable prices. I have a lot of local Muslim customers too, which was a pleasant surprise as I thought they would go to the Indian barber shops nearby instead. They tend to have different preferences for how they like their beards, so that's something I had to get used to and earn their trust, but they take a lot of pride in the way they look and have very high standards. In the barbering world it's always about maintaining the same standards every time. If your standards start dropping because you get too comfortable, your customer will start looking for different options.

SAMARA
URBAN FOOD FEST STAFF

I like my job because I love talking to people and I can honestly say the street food here is good!

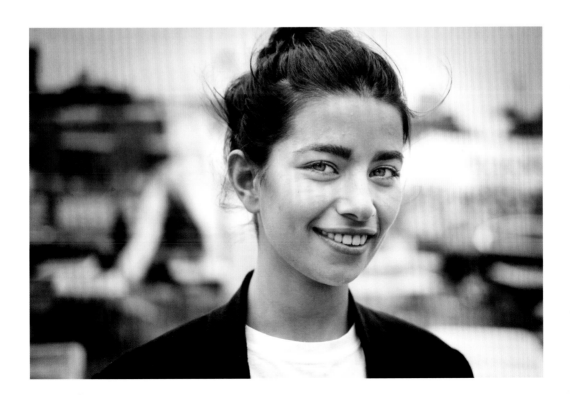

BRIDGETTE
FLORIST

I've been working here for around two years now. I like working with young people here and our customers who come in, as they are a younger demographic as well. People trust you to do something a bit different, and more creative, than the older generations. During the week it's a bit more corporate, but we also get a lot of work from design studios and creative companies who give you more freedom, so that's nice. To sum up why I like Shoreditch, I'd say it's because it's so lively!

KAM AND FLORENCE
LOCAL COLLEGE STUDENTS (MUSIC AND ART RESPECTIVELY)

I grew up here, just around the corner. Shoreditch is ... loud, very loud!

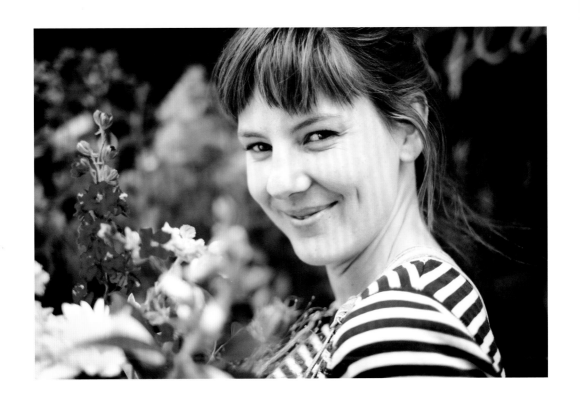
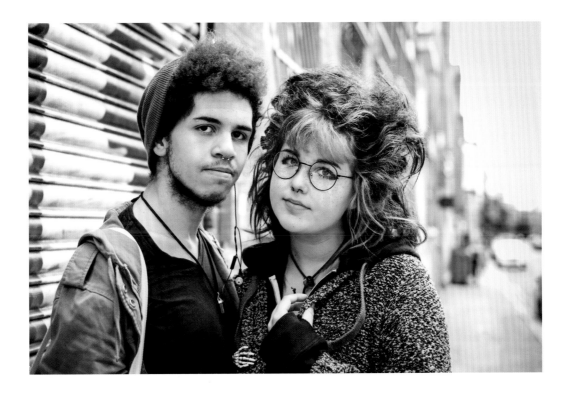

FACES OF SHOREDITCH

JOEL
FRONT OF HOUSE AT NOT ANOTHER SALON

Shoreditch? There's no other place like it.

RAMZY
EDITOR, *HACKNEY GAZETTE*

I started my career on work experience at the Hackney Gazette, choosing it almost at random at the time – and I'm here as the editor five years later! Our stories range widely in theme, covering anything from crime to education with a link to Hackney. Shoreditch is an area with a very disconnected history, a working-class background contrasting with the new, more well-off people moving in, which has caused some tension. The Gazette is more of a working-class paper; our readers are mostly those who have been living here for a while, though not for want of trying to attract newer people as well! I think there's a general perception that a local paper isn't something for people who have come into the area recently and we make sure there's plenty for those who have spent time here and feel connected to the area on a deeper level. But a good story is a good story, and we're trying to get more involved with Hackney schools and businesses to make sure we reflect the whole of the borough.

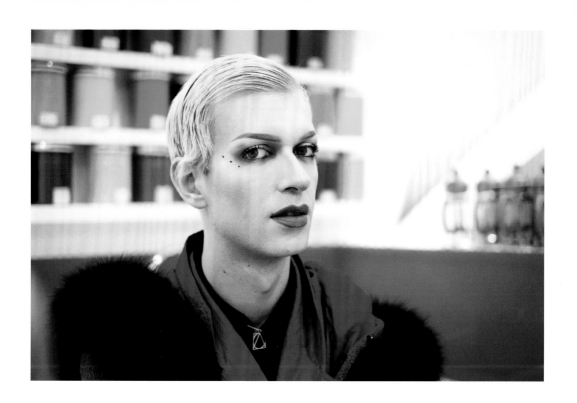

SCOTT (AND ROSCOE)
INSURANCE CLAIMS HANDLER

East London is my favourite area. I don't ever go West really.

KAROLINA
MARKETING MANAGER

My boyfriend and many friends live around here, so we usually hang out in this area — I love the vibe and the cute independent places. I'm into fashion, and I'm always inspired by the eclectic street style you see around here.

FACES OF SHOREDITCH

MANDY
LOCAL RESIDENT

This is an area of freedom. Energetic and a bit messy ... but so much more exciting than anywhere else.

YANIV
CO-FOUNDER, THE SHOREDITCH BEARD

I started The Shoreditch Beard with two of my friends, Gianluca and Elise. We set it up during a weekend. Since we work in tech, and love living in such a creative area, this was the perfect way for us to bring those things together. Our brand and products are very much inspired by Shoreditch. We live here, work here, have friends here, and we have beards – except Elise of course! I really believe that if you drive more talent into this area it'll benefit long-time residents as well. A person now born in Shoreditch has a better chance to get into a good job, in the tech industry for example, than fifty years ago when they could've gone to work at one of the factories. But I do think a set of measures should be implemented to control rents and help small businesses keep their doors open. I have a friend who had to close their cafe when Costa moved in around the corner, for example. They should put things in place to make sure people can stay.

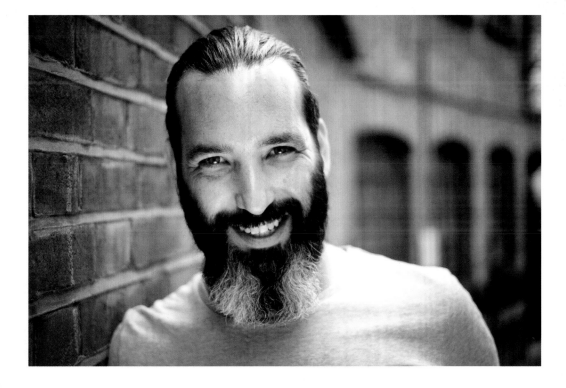

THOM
MANAGER, THE GRIFFIN PUB

We recently reopened the pub following renovations. The building is Grade II-listed, including this part behind the bar with the columns and mirrors, and we have to preserve the character of the place since it was part of the terms when we applied to get permits for the work that was planned. If the mirrors break for example, we can't just replace them with new ones.

ROBERT (AND FRIEND DONAL)
LOCAL RESIDENT

Shoreditch is mad, absolutely mad, but life is beautiful! We've been friends for a long time, and sometimes it's nice to just sit here and relax with some good wine in hand. I've been here since 1956 and I'm still working, you know. I have to, otherwise I'd die! You know, I went to get my teeth done once, and the assistant told me I can get a set that'd last me twenty years. I told her, honey, in twenty years my face will just be a skeleton in the ground, but at least it'll have perfect teeth!

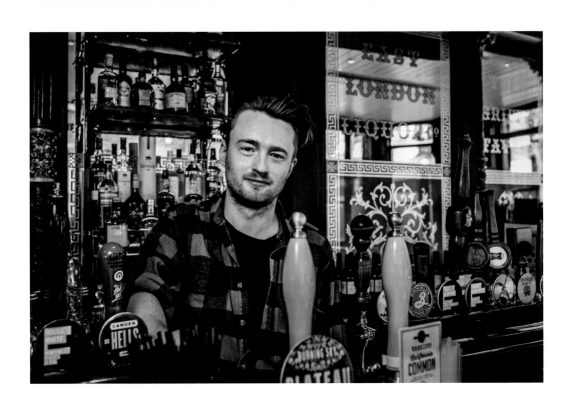

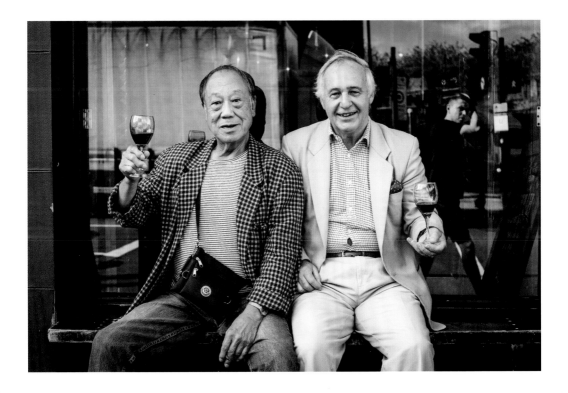

CAROLINE BARLOW
FOUNDER, ARTS FOR ALL COMMUNITY CENTRE

I founded Arts for All over fifteen years ago. I've lived in Shoreditch for most of my adult life and had previously worked in teaching and as a voluntary youth worker. I was always very interested in arts and crafts and knew that lives can change when you add an element of creativity. We were given the opportunity to move into the Tab Centre for a very low rent because it was derelict. We built it up little by little: one class for children, one class for adults. It's grown a lot and has been a registered charity since 2003.

We work with two main groups: children and families, and vulnerable adults. We support children from a very young age. Although most of our members hear about us through word of mouth, we also get referrals from the National Autistic Society, social services, and schools. Our aim is for the children to feel happy, safe, and able to reach their full potential thanks to the care and support they receive.

I feel completely committed to supporting isolated and disadvantaged people from this community. I find it hard when benefits are cut and it feels like the most vulnerable people are being targeted. Our work with adults with learning disabilities and pensioners is free for the members and we try to ensure that we give them a great day each week with lunch thrown in. We also organise trips and experiences for them at no cost.

But all of these things cost money, and I have to do all the applications to trusts, foundations and companies. It is really hard work and I often have to work six long days a week in order to get all of it done. I have amazing support from my staff and volunteers but at the end of the day I have to take responsibility for the secure future of this charity. There are lots of things I'd like to do still. I'd love to work with toddlers, or add a second day of classes for adults with learning disabilities. But that's never going to happen unless we can raise more funds. We need over £100,000 each year to keep these vital programmes running and we always really appreciate any support, monetary or otherwise.

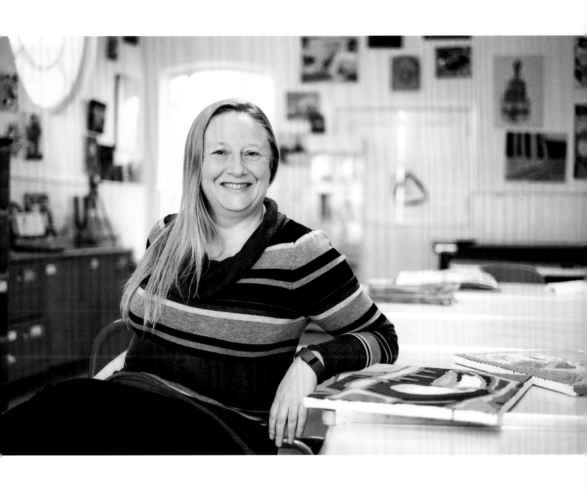

KYLIE
DESIGNER

I've just been to the cat café. It's so nice to find such quirky places around here!

PETER
CARPENTER

I was born nearby and moved to this estate when I was seventeen. The estate was originally opened by the king in 1901, and it was featured on the BBC show The Victorian Slum! The people in it actually came here, into our stairwell, and were told they might be offered one of these flats to live in during that period of the show, but only the family with enough money could get it — after all, you had to be wealthy to be able to rent something here at the time. Not that these days it's much different, mind. We've lost our favourite Indian restaurant due to the rent hikes — the husband and wife who used to run it had to sell it and now it's a burger bar or something. We were so sad. It was a real gem. That street used to be semi-derelict. Now you've got Saatchi and the likes moving in… it's really being sanitised.

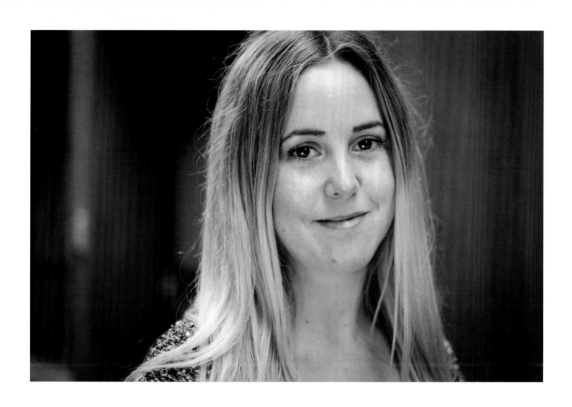

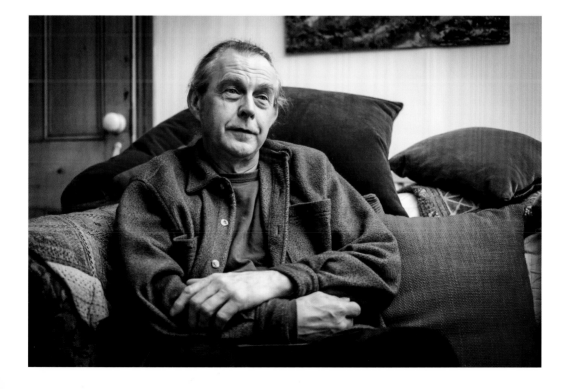

FACES OF SHOREDITCH

LEE
PLASTERER AND PART-TIME MODEL

I used to run an online vintage clothing store; now I work as a plasterer and do some modelling on the side. I used to live in Shoreditch, and other parts of East London, for a few years until I couldn't afford to spend so much on rent any more. No chance of being able to afford buying a place either, so I bought a boat and live there now.

RAY
HOTEL MANAGER, THE COURTHOUSE HOTEL

I open luxury lifestyle hotels — that's my thing! I started out in South Africa and then moved on to the London scene, where I've found continued success. The most memorable point in my career was organising a Banksy exhibition and auction at ME London. There were things like salvaged containers, murals, and all kinds of other random bits and pieces with his artwork! Banksy himself was probably there incognito — we joked that he might be one of the waiters or other staff, who knows! I love working on things that are original and unique. Here at the Courthouse I can do that a lot, because it's where the old magistrate's court was, with lots of opportunities to play on that theme; for example, part of the building is the old police station, complete with prison cells, including the actual former cells of Ronnie and Reggie Kray when they were guests of Her Majesty. We've converted those slightly to include seating areas for guests, but the only way to get that permit from the council was a clause requiring us to keep at least one of the cells in its original state, which includes the original toilet. Unfortunately, we had to cover it up and nail it shut, because at one point a guest thought it was a real working one...

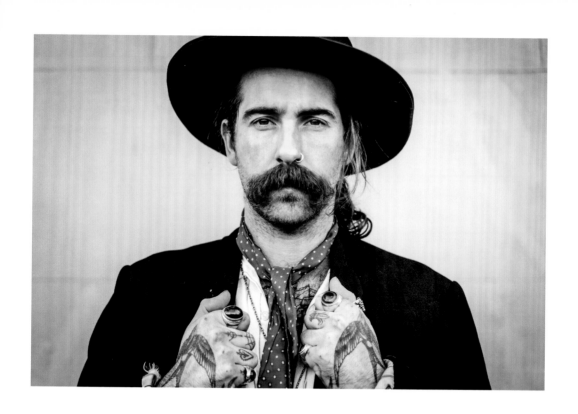

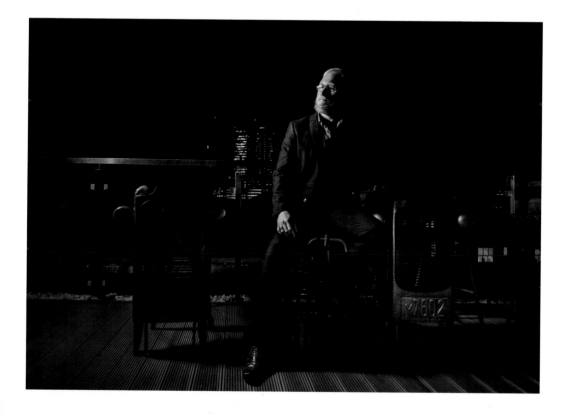

STACEY CLARE
CO-FOUNDER, EAST LONDON STRIPPERS' COLLECTIVE

Do I still strip? Well, I've become fussy about where I work. There are few places left in the UK that aren't exploiting dancers. I'm also a bookkeeper in an art gallery. I've been doing that for a couple of years, and I run other events as well. The whole East London Strippers' Collective idea has been taking off so it's taking up quite a lot of my time to co-ordinate it all.

I started stripping ten years ago, when I was a student and needed some money. I was really attracted to the glamour of it, but I had always noticed the exploitation of us having to pay to work. We had to pay the clubs a fee, and if the club was empty, we were sitting there with no one to dance for and often had to go home with nothing. We don't have contracts. There's absolutely no worker protection, so we could be sacked without literally a moment's notice. You don't have any disciplinary procedures, no process for grievances, there's no employment tribunal, basically no rights at all. However, I just don't agree with shutting down the industry completely. There are so many women who want to try it.

The Collective started when I felt that I'd seen enough. I couldn't find a place in London that I wanted to work in anymore, and thought that there are hardly any places in the industry that are run by ex-dancers. I thought we could do something ourselves, putting our resources together. The stripper friends that I've got are also designers and photographers, writers and mothers, very capable, strong and talented women. My whole thing is about doing events and mini-opportunities for dancers to do their job, but in a different context for a different audience, in a much more positive environment. Where badly run strip clubs that exploit women have a negative social impact, well-run strip clubs, where dancers feel respected and valued and to some extent empowered, can have positive social impact. I still love performing and that's why we're going to run our own events and eventually our own place. That's the whole idea with the Collective. If we can't find a place where we're happy to work, we'll create one ourselves.

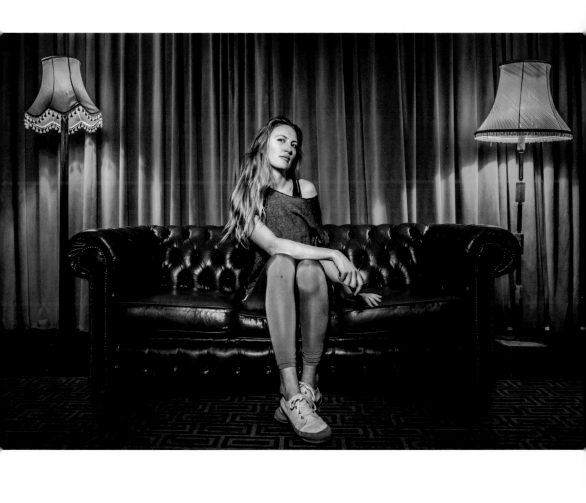

FACES OF SHOREDITCH

RITA
PRODUCER/PERFORMER, LUCHA VAVOOM

I produce a Mexican wrestling and burlesque show and we're scheduled to appear at Bestival next year. My husband is British and we try to divide our time between here and the US. Shoreditch isn't like it was in the 90s, when it was much more independent and crazy, but I still come and check out the shops when I can.

PADDY
MANAGER, LIBRERIA BOOKSHOP

Here at Libreria, our aim is to reimagine what it's like to discover something new. I draw on my past experience in content curation to come up with creative ways to display our books, mixing fiction with non-fiction, for example, around non-traditional themes. For example, we have Geoff Manaugh's A Burglar's Guide to the City *among some architecture books, as a creative take on the topic. The beauty of this is that our customers also end up being all kinds of people, from all walks of life, sometimes travelling quite far to browse at our shop after hearing about the diversity of the selection. If a book people ask about isn't available in the UK, we go as far as to import it from overseas if we can! As for my favourite book? That's easy:* Ulysses *by James Joyce. I don't often use the word genius, but there is some of that in the way Joyce foresees twentieth-century creativity, the concepts of neuroscience, biology, language... every section is so different and so incredible.*

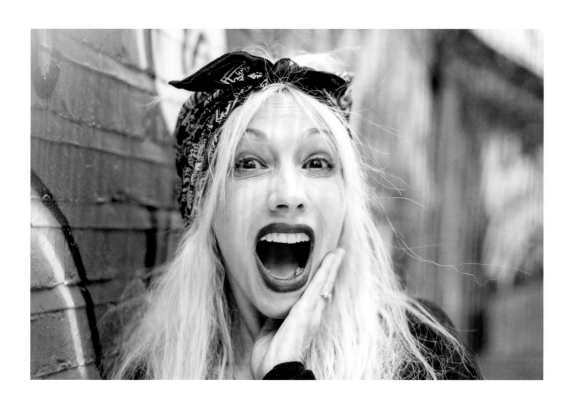

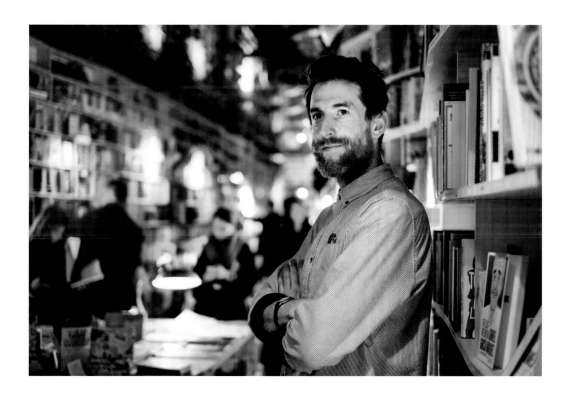

FACES OF SHOREDITCH

MONICA
SHOP ASSISTANT

I come from a small Italian town, and you don't see as many different, colourful people there as you do in Shoreditch. I love that everyone can express themselves and say and do anything they like.

BRIAN
LOCAL RESIDENT/PHOTOGRAPHER

There was a large furniture company in Tottenham called Harris Lebus Ltd. At the time, it was the largest furniture manufacturer in the world. I was there for about fifteen years as a photographer, taking pictures of the furniture and working in the darkroom. That was in North London, and there were some real villains there. Shoreditch was bad too. Forty, fifty years ago it was not the place to live in. But now this area is actually very quiet and peaceful. Where I live is Europe's oldest social estate. When I moved into this flat in '72, there were lots of Jewish people living here. That sort of Jewish food was gorgeous – shame you can't get it now... But the Bangladeshi people who have moved in since then are also very nice. Shoreditch has changed a lot by now. I was talking to somebody the other day and I said, 'Why are you interested in Shoreditch?' She said it's changing so rapidly. Apart from the people who live here, a lot of the previous homes have been rented out for profit.

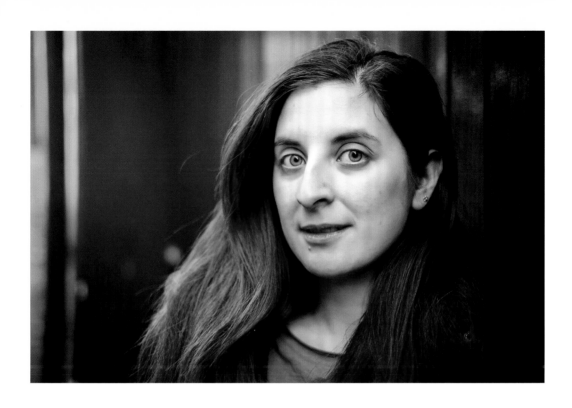

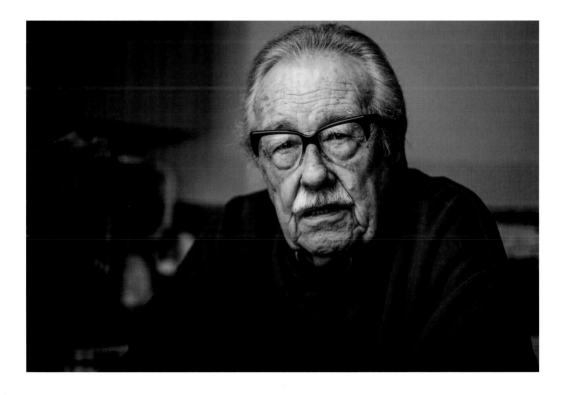

FEYA BUCHWALD
OWNER, BRICK LANE BIKES

This place feels like more of a community than the rest of London. You can stay in the area and go for dinner, go to clubs, walk or cycle everywhere, and be in a place where everything's within your reach. My previous experience of London life in other areas was that the distances were too big so you had to plan your time more; this area has a much freer vibe.

Before cycling became popular all over London, it was already popular here – there were no train connections to the city before the Overground station was opened, so this was the only way to get around unless you took the bus. At first it was mostly commuters who came into the shop, but then more and more local designers and fashionable types came as well. Lots of our staff used to live around here too – not anymore though as they've been priced out. In Shoreditch you can actually see the progression of the city; it's evolving in front of you at a fast-forward speed … someone left for two years and came back, and was shocked at the changes.

Our standard customer ten years ago was likely in the arts or design profession – probably 90 per cent of them were linked to that in some way, wanting something custom designed and willing to pay a bit more for it. We still have them, but also a lot more everyday customers who are looking for a basic bike to ride around. My own bike is a vintage Italian frame, but we test a lot of our own parts all the time, changing them up, so it's not that exciting compared to my husband's bikes; he has lots of them!

THE REVEREND PAUL TURP
VICAR, ST LEONARD'S CHURCH

I was born in Highbury, and I first saw this church when I was eight. I remember seeing the outside of it. The next time I saw it was when the Area Dean brought me in here to see if I'd have the job. Thirty-three years later I'm still here.

Bishop Jim Thompson broke the rules to ordain me into being a vicar at this church. He looked at my background and CV and said, we can have him – that's how I got to be here. It was derelict, and the bishop had told me that there's no future in this church. The building's a ruin, hardly anybody lives in the parish and a third of them are Muslims, so what are you going to do? The Church of England wanted to close the place. But it has more history than any other church in London, so I thought that if you close it that's a huge statement to the world out there.

In 2001 we closed the church for a couple of years to do the work, and spent £1.56 million, coming from the Heritage lottery fund. It's not done yet though and there is still more work needed to restore everything. We are a very poor church financially. I think I have spent over £2 million on the building all in all, which soaks my energy. I'm meant to be doing the saving souls business! But I have some good people working with me.

On the corner, there's Acorn House – I built that too. It has seventeen residential units for people in addiction recovery. And our success rate is extraordinary. The coffee shop outside the church is run by people in recovery; in fact most of what happens in the church is done by them.

With all that said, I'm not exactly a maverick, but I don't fit the right parish priest mould either. Being sixty-seven years old though, it doesn't matter. At this point you could be bonkers if you want, because you have to retire at seventy anyway. As far as the Church is concerned, they know that I rescued a very important historic building and I make it work it for the community while maintaining its spiritual life as a church – that presses all the right buttons. I do know what I'm doing, even though I do a lot of things without knowing how it's all going to end up. I think that's what Christian life is about: doing things without necessarily being sure how they'll end up. Because if you did, and knew the cost of getting there, you might not do anything at all.

FACES OF SHOREDITCH

JOHNNY
ILLUSTRATOR

I used to know that building there, on Curtain Road. That was a great old factory when I knew it. I used to go raving in there, but I don't go to those mad crazy parties these days. Lots of my friends were putting them on back in the day but now it's not like it was; you can't break into an old warehouse and rave. But I'm old so I don't know what the young people do. They are closing all the clubs down. Everything is flats now. I guess some people think it's all changes for the better... But we used to people watch from that balcony, and now I've just looked up and seen what it is — it's horrible. I think it's all apartments now.

When artists move in somewhere, isn't it terrible in a way when they do, because then everything that was good in the area gets knocked down and made into swanky apartments, making the place not what it used to be like at all. Rather than encouraging it they should be discouraged, because the artists indirectly destroy what they came to celebrate. What I mean is that the artists make an area trendy and then everything gets knocked down. I'm going to draw some signs saying 'Artists are not wanted here, artists you must move on!' They are destroying Deptford now. I bet they've destroyed Peckham already. You won't meet anyone my age that thinks London is better now than it was before.

FACES OF SHOREDITCH

TANYA PEIXOTO
OWNER, BOOKARTBOOKSHOP

Bookartbookshop opened on a palindromic date, 20.02.2002, and in that spirit we've had fourteen years of meaningful engagement with book artists at all levels of their career. I opened the shop because there was nowhere in London where you could view, handle and buy artists' books all year round. Alastair Brotchie, director of Atlas Press, offered me his shop on excellent terms after a talk I gave at the Artist Bookfair at the Barbican in November 2000, and now we are celebrating sixteen years of love and creative collaboration. During this time the bookshop has seen great changes in Shoreditch, but somehow we've always managed to attract wonderful customers and bookmakers who are very appreciative of the quirky quality of the shop. One of our favourite visitors is the street artist Stik. Early on he made a simple little pencil-drawn, book stab-bound together, which we sold for a few quid. It must be worth a small fortune now. It is clear that you won't find anything 'useful' in the bookshop — more likely something you didn't know you were looking for. But there is always a warm welcome for those who are passionate about books, book art and the imagination.

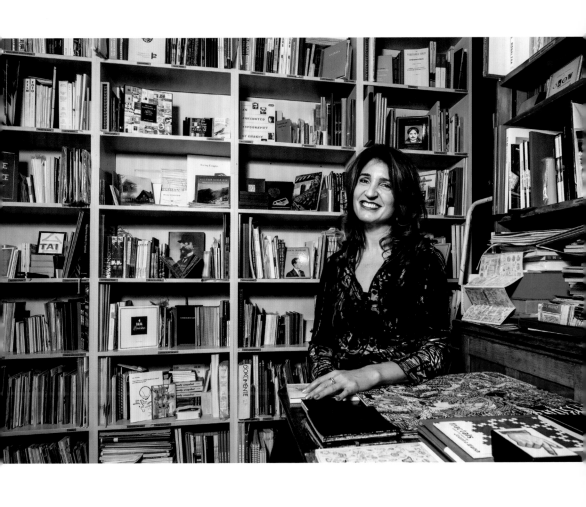

MARK
CREATIVE DIRECTOR AT THE CULT OF SIR

My fashion inspiration is myself, I think. When I see interesting patterns or fabrics, I put them together or make something from them. Actually, Iris Apfel is also inspiring. She's nearly a hundred yet she's still always so well dressed!

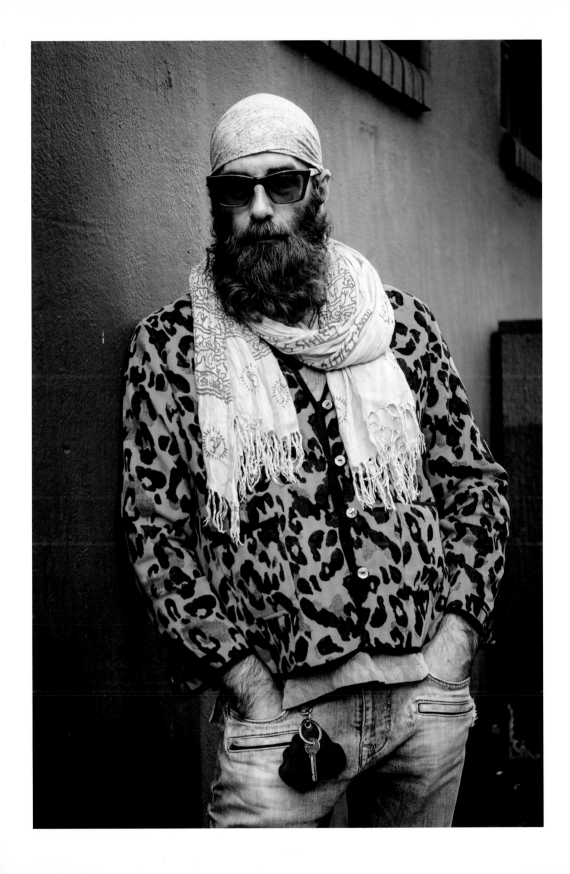

MARK
TATTOO ARTIST, PARLOUR TATTOO

There are four of us running this place at the moment; I feel we have a well-rounded partnership. This is our first shop, so we are aiming to make it a welcoming place: nothing too cool for school, something for everyone, and a nice place to work for our artists. Shoreditch is a melting pot of different cultures, and the people we tattoo are from all walks of life. One client, for example, was a ninety-year-old man! I've had some interesting tattoo experiences. I let my son tattoo his name on my leg when he was five, so I've got 'Oliver' written on my leg. That's probably my favourite tattoo. The most memorable one I've ever done was a portrait of my nan, on my uncle, but I've done some bizarre stuff as well that I won't get into … I started tattooing out of my bedroom. I had to get into it; I've always wanted to. I love tattooing and everything about it. It doesn't feel like work when you enjoy something this much and I couldn't think of a better place for a parlour than Shoreditch.

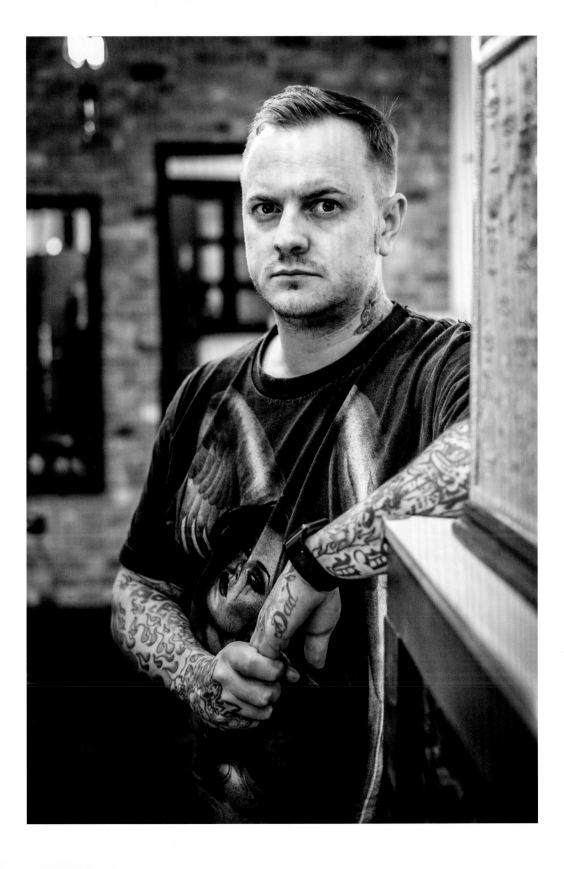

HRISTOS
BREAD MAKER

Shoreditch is spontaneous and it always keeps you guessing!

JEAN
LOCAL RESIDENT

My mum lived in Hoxton, and when I did some research on my family tree based on census information, I found out I had other ancestors in this area in the 1890s. I moved back with my husband, and now I take part in various community activities. There is a charity, Friends of Arnold Circus, consisting of volunteers, who initially began to just plant bulbs and wild flowers on the circus, but now we have a gardener to keep Arnold Circus looking nice. The Boundary TRA opened a not-for-profit community launderette over twenty years ago, initially with charitable funds, and it's been doing well ever since, but there has been so much change over those years. There weren't many shops at all, just a '7-11' that wasn't even open during those hours, no supermarket … and now we're spoilt for choice! When we used to go out on Saturdays we hardly saw anyone. Now we sometimes have to move people on at 2 a.m., people who are drinking on the street outside our window – there are lots of rough sleepers. The changes are exponential. I've stopped counting all the new buildings but still object if they appear to threaten the area.

FACES OF SHOREDITCH

CHRIS GREENWOOD
CO-OWNER, BEDROOM BAR

I first worked in Shoreditch when I opened Cargo in December 2000. I had previously run clubs and venues in Soho. Shoreditch had interesting buildings, a fantastic community of artists, rogues and misfits and, crucially, relatively low rents. That's all over now of course … For me, it's game over. Greed and opportunism have won the day. We had attracted an audience interested in live music and stand-up comedy, with many regulars and a strong community, but I have a new venue in Walworth Road where it's similarly strong, and I'm also working on a spot in Hackney Wick.

FACES OF SHOREDITCH

LYNDA
LOCAL RESIDENT AND ARTS CHARITY VOLUNTEER

I found myself moving here with my children not entirely by choice, but by coincidence and circumstance. I used to love painting a long time ago, before I got married. Once I got married I lost all inspiration; I could not paint anything at all. But since I moved here, slowly, I am coming back into my element. I live near the building where the Arts for All charity is based. When my kids started going to school, I noticed that there were some children from there going into the building, and I was curious to know what was going on in there. Since then it became a routine and addiction. I volunteer to help with the clubs for the kids. It's a nice atmosphere, which is very rewarding on a personal level. My children love it too.

ADAM
BRICKLAYER

As far as I know, a West Ham footballer has bought a place in this block we're building. Personally, I don't understand why anyone would want to pay millions for a place in this rundown area.

FACES OF SHOREDITCH

PATRICK
CINEMA MANAGER, ELECTRIC CINEMA

I used to work in Shoreditch for years, starting out as a barman in the Strongroom pub in in 1999. A friend of my started an outdoor cinema company, so I got involved in helping with the rigging for that, going around London – five nights a week during the summer. Eventually I got work at the Aubin Cinema. Soho House, who own it, stripped it back, rebuilt it and Electric Cinema Shoreditch was born! We also have a restaurant, barbers and hair & nail salon all in the same building. It's unlike anywhere else.

The projection room used to be between those two pillars but since we stripped out the 35mm and went digital, it's now a cupboard! A very nice cupboard though. Now that it's done, when I can, I sit here in one of the armchairs to do my work. It's brilliant. Soho House is a great company to work for. I am really proud of what we are and what we add to cinema in London in general.

We are probably one of the only remaining companies that have dedicated projectionists. Because we offer a luxury cinematic experience, we must have our bases covered, you know? When you work in multiplexes without a projection team, the only way you find out something has gone wrong is when a customer comes out to tell you they're looking at a black screen. I feel like it's nice to work for a company who care about presentation and creating an experience. I'm amazed by how well we do in terms of occupancy, especially for a one-screen cinema. We have regulars who come, for example an older couple who always get their usual seats, or a guy who used to come on dates with various women each week – although I haven't seen him for a while so he must have settled down with someone!